Drawing Trees

DENIS JOHN-NAYLOR

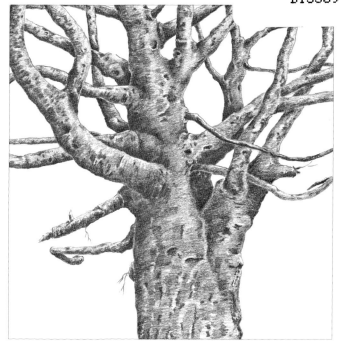

SEARCH PRESS

This edition first published 2014

Search Press Limited
Wellwood, North Farm Road,
Tunbridge Wells, Kent TN2 3DR

Originally published in Great Britain 2004

Text and illustrations copyright © Denis Naylor 2004
Photographs by Roddy Paine Photographic Studios
Photographs and design copyright © Search Press Ltd. 2004

ISBN 978 1 84448 979 4

The publishers and author can accept no responsibility for any
consequences arising from the information, advice or instructions
given in this publication.

The publishers and author would like to thank
Winsor & Newton for supplying many of the
materials used in this book.

Suppliers
If you have difficulty in obtaining any of the materials and
equipment mentioned in this book, then please visit the
Search Press website: www.searchpress.com

Publishers' note

All the step-by-step photographs in this book feature the
author, Denis John-Naylor, demonstrating his drawing
techniques. No models have been used.

Printed in Malaysia

*Many thanks to Roz, Sophie, Juan and all
at Search Press.*

Page 1
Sunshine and Shadows
120 x 180mm (4¾ x 7in)
*It is the dark tones in contrast to the white paper that give the
impression of light in a drawing such as this.*

Page 3
Maple Branches in Winter
190 x 203mm (7½ x 8in)
*This pencil drawing was worked up from a small ballpoint
pen sketch. I enjoyed the discipline of arranging the positive
elements along with the negative spaces.*

Opposite
Old Leaves and New Buds
260 x 330mm (10¼ x 13in)
*I found this section of branch and leaves on a morning walk,
brought it home and drew it straight away. I like the fact that
it shows a link between this year's worn out leaves and the
buds of next year's new growth.*

Contents

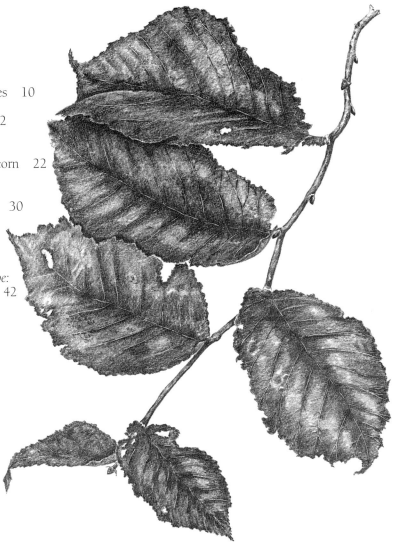

Introduction

Having decided to learn how to draw trees, or improve your existing skills, you will want to make fast progress. It is the aim of this book to help you succeed at this. You will be shown in easy stages how to draw trees to a high standard and to a high level of satisfaction. Trees are as individual as people and must therefore be approached as such by the artist.

Drawing trees for enjoyment, or making finished works, has its advantages because of the endless supply of models available. Trees, shrubs and a variety of foliage are in plentiful supply most of the time, almost regardless of where you live. You can observe them at close quarters or from afar, with or without their leaves, seeds and fruits. Photographs, magazines and books, as well as television programmes, are also useful sources of information.

It is no coincidence that the most proficient artists are those who draw often and persistently. It is this frequent practice that will most rapidly develop your ability. You will learn how to organise your tree drawing in terms of shape, form and texture, and how to introduce variety into your drawings through the skilful use of line and tone. Just as importantly, practice will aid the development of your all-round drawing skills and add to your progress as a developing artist.

In learning from this book, you may initially adopt my methods, but please always try to make time to experiment for yourself. This will help you to develop your own approach and allow your own unique style to emerge.

Success is within anyone's reach. Your rewards will soon come if you make a determined and consistent effort. Do not concern yourself with how long your drawings take, but with what you achieve and learn with each one. Art is not instant. Good luck!

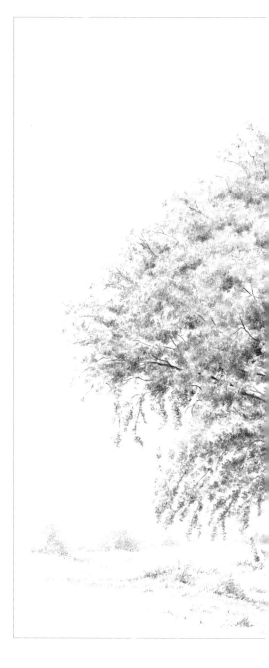

White Willow
370 x 285mm (14½ x 11¼in)
A magnificent tree in full leaf.

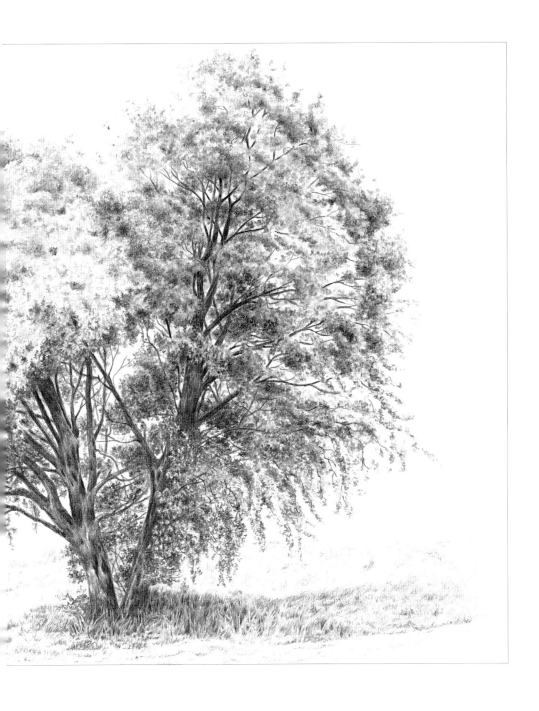

Materials

There is nothing worse than buying expensive paper and pencils and being too inhibited to use them, thinking that your efforts will not do them justice. This becomes a stumbling block to progress and certainly spoils the enjoyment you should otherwise feel.

If you think that this may be you, I suggest starting with photocopier paper or an economy sketchpad and a black ballpoint pen or 2B pencil. All the initial exercises can be done with this minimum of equipment. You will benefit considerably by the positive approach required when using a simple ballpoint pen in particular, since this removes the option of rubbing out errors.

Inexpensive drawing equipment: photocopier paper, economy sketchpads, a black ballpoint pen and a 2B pencil.

As you progress you will need soft pencils: grades 2B, 4B and 6B, a putty eraser, craft knife, an A4 pad of 80gsm drawing paper, heavyweight (220gsm) cartridge paper, watercolour paper, a paper rubbing stump and a plastic eraser.

Pencils are best sharpened to a long point using a craft knife, for use on their side or to lay down broad areas of tone.

The value of a kneadable putty eraser is that you can take it from its wrapper and break off about a third, and work it between your fingers until it is soft and pliable. Each time you use it, re-knead it so that you always have a clean surface to work with. These erasers do eventually get to the point where they carry too much removed graphite and start to smudge. Discard the piece and knead another ready for use. The art gum or modern plastic eraser can be cut into strips and sharpened like a pencil for detailed use. These erasers can also be used for making marks in your drawing and are not restricted to removing errors.

An impressing tool is used to impress grooves in the paper, which you can then tone over with a pencil, leaving fine lines clear.

Save small pieces of clean, plain paper and card to experiment on. Make a mental note of the various surface textures and the effects achieved on them, for future use in your drawings.

Materials for sketching outdoors

When drawing outside I always have elastic bands to keep the pages of my sketchpad from blowing over. I also have pieces of photocopier paper cut to my sketchbook size to place between the most recent pages used, to prevent the drawings from pressing off on to facing pages.

If I am sketching with a ballpoint pen, I also have a piece of paper tissue to wipe the point when the ink builds up on it. This can otherwise be deposited on to the drawing as a blob.

All the equipment you will need for drawing trees: elastic bands for sketching outdoors, a craft knife for sharpening pencils, a paper rubbing stump (tortillon), pencils, an impressing tool (a clutch pencil with a small nail held in it), putty and plastic erasers, paper tissue for wiping ballpoint pens, tracing paper, paper and sketchpads.

Tips and techniques

Sharpen your pencils to a long point using a sharp craft knife. Harder pencils generally give lighter tones, and softer grades give darker tones. Much depends on the amount of pressure you use.

Always have a piece of clean scrap paper under your drawing hand to keep your work clean. Make sure you lift rather than slide it to a new position, to avoid smudging.

After sharpening a pencil, strike it on a piece of scrap paper to smooth the working side or end, ensuring that you get the mark you want when you begin your drawing. Repeat this process every time you pick up a pencil to resume drawing.

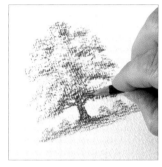

Using a gentle circular motion with the side of the pencil will pick up the paper grain to produce various textural effects. The example above was done on Not surface watercolour paper.

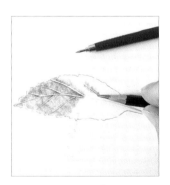

Impressing grooves into the paper with a fingernail or impressing tool allows you to tone over with a pencil, leaving delicate lines clear.

Lay down an area of tone, then use a rubbing stump (tortillon) to spread and smooth out the pencil marks.

Mould your putty eraser to a point or flat edge and use it to draw fine lines into areas of tone. A dabbing motion will delicately lift tones. Do not let too much graphite build up on the eraser before remoulding to make a clean edge.

Ballpoint pen techniques

The familiar ballpoint pen is excellent for sketching work. Not being able to remove errors will make you more positive in your drawing. Use some plain photocopier paper to do some simple trials. Remove excess ink from around the ball frequently, using paper tissue.

Test the range of tones possible with a ballpoint pen. Start very lightly and gradually build up pressure, making the lines closer together as you progress.

Try these tests to see how well your pen reacts. There should be little sign of 'blobbing' at the high points of the curves.

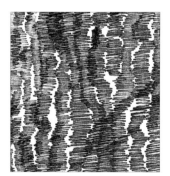

Make up your own bark textures with horizontal or vertical shading.

Overlaying light marks with heavier ones produces three tones with the white of the paper.

Getting started

Consider all drawing as a process of making marks. These marks should be designed or arranged to give the viewer of the work the illusion that they are looking at a three-dimensional image. Concentrate on getting some variety into the marks and lines you produce. This is where sketching is so useful. Genuine sketching will help you achieve nice, loose line work because you can experiment and enjoy the sheer pleasure of looking and learning. You do not have to show your early efforts to anyone unless you want to. Keep all your work, as it will motivate you when you see evidence of progress. It may also encourage you to examine your mistakes and seek ways of correcting them.

Try these simple examples for yourself, and see what variety you can get into your line work.

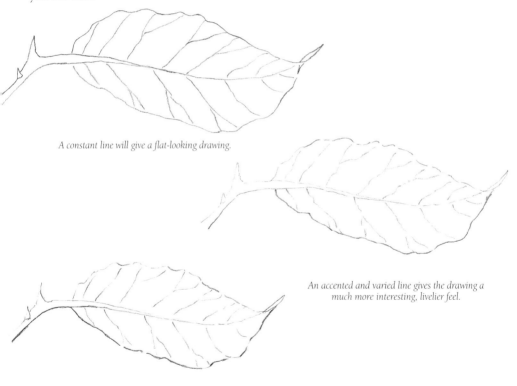

A constant line will give a flat-looking drawing.

An accented and varied line gives the drawing a much more interesting, livelier feel.

Using a soft pencil creates a softer and more broken accented and varied line.

Proportions and angles

It is not usually critical to draw the exact proportions of any given tree. However, you can improve the accuracy of your drawing by using a method known as measured drawing. I do this as follows: with my arm out straight, one eye closed and holding my pencil horizontally, I use it to gauge the width of the whole tree. Retaining this gauged reference, from tip of pencil to thumb, I now turn it vertical to compare it with the height of the tree. If the height and width are similar, I lightly draw a square on my paper to the required size, where I want my finished tree to be. In other cases where the width and height differ I draw a rectangle to the correct proportions, upright or on its side. My tree will now fit inside this shape and be placed to suit my composition.

I now consider the trunk of the tree. I gauge the width as before. This reference may now be used to approximate the relative proportion of any other feature, such as how far up an intersection of branches occurs. These other features will then be one, three or however many times the size of the trunk.

Using these approximate measurements, I make light marks on my paper. This helps me to check that the drawing will fit into my overall shape. Now I make light guide lines to indicate the angles of the branches. I align my pencil,

This measured drawing shows how I have used the width of the tree's trunk as a guide to the proportions of the whole tree. I have also noted the angles of the branches.

with one eye shut and arm outstretched, along the branch or trunk in front of me and carefully transfer this angle to the drawing. I note where the branch angle crosses other points on the tree and check this with either comparative measurements or angles, or both if it is important enough. When I feel that I have enough guide marks and angled lines, I begin drawing the tree proper. I continue this checking process until I am satisfied with my outline drawing. I do not, at first, remove any incorrect lines but use them as a guide to place a more accurate line. Only then is the inaccurate line erased.

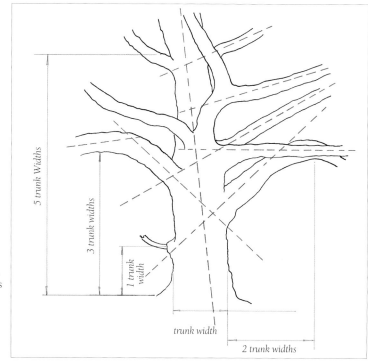

5 trunk Widths

3 trunk widths

1 trunk width

trunk width

2 trunk widths

Shape, form and texture

Another organised way of working through your drawing is to go through shape, form and textures steps. Students or beginners often tend to see the most obvious features first and draw these in too early in the process.

Shape

Start by looking carefully at the shape or outline only. Spend time setting this down as accurately as you can. Begin by making small marks for the height and width of the subject at various points, checking the proportions by measured drawing (see page 13) and marking where the tree shape changes occur. This needs to be done lightly at first, making any corrections before using bolder line work. Use the point of the 2B pencil. Trees and other objects do not really have lines around them; it is a drawing convention to put these in at the outset but the lines will need to be lost in the finished drawing.

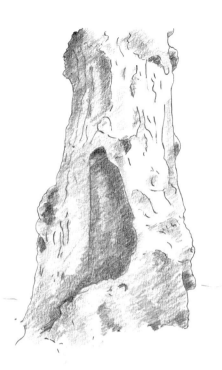

Form

I next look very carefully for the change in general form (lights and darks). The form is shown by the fall of light. Indicate the shadow areas with the application of tone. Start lightly before making strong marks, to make any subsequent changes easier. Large internal features may be put in at this stage, such as the part hollow in this tree trunk. Use the side of a 2B pencil for initial work, followed by the side of a 4B pencil for darker tones.

Texture

When I have established both the shape and form to my satisfaction, the texture may be added: the surface marks that indicate the tree's smoothness or roughness. The tonal value of these textural marks will largely follow the general tone of the trunk area on which they appear. Looking carefully at textural marks will often reveal that they appear larger and further apart on the surface nearer to the viewer and closer together as they disappear round the sides of the tree trunk. Good observation here will add greatly to the reality of your drawing. Use both 4B and 6B pencils on their points and sides to obtain rich darks.

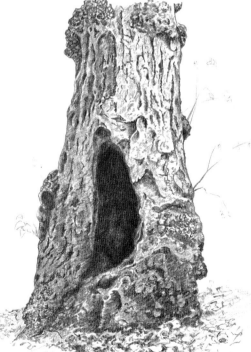

Sketching

Use a pocket size 6 x 4in (15½ x 10cm) sketchbook and a 4B pencil or black ballpoint pen. Using a pen may seem intimidating but will make you look and think more before you put marks down. Whether you begin with pen or pencil, put your initial marks and lines down lightly and loosely as a guide only. Use these to help you position more accurate marks and lines. Gradually make your marks more positive as your sketch develops. When you are satisfied with this structure, you can build up a variety of tones to give the effect of light and dark. Try sketching trees with the light coming from one side. This will help you to see the tonal changes across the subject. I often sketch the same tree many times, but I still see more each time. The more you see, the better your drawings and sketches will become.

It is as much the position of the lights and darks as the actual contours of the tree parts that tells the viewer where the branches come from and go to. The use of tone also indicates where they are in space relative to each other.

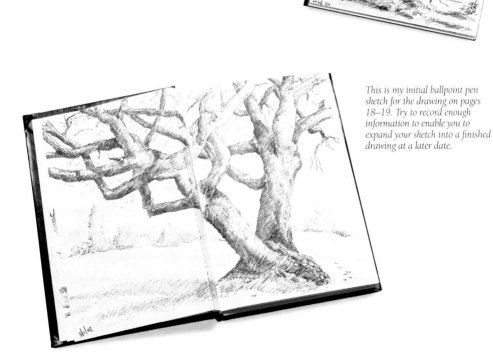

This is my initial ballpoint pen sketch for the drawing on pages 18–19. Try to record enough information to enable you to expand your sketch into a finished drawing at a later date.

Quick sketches like these two can be achieved by using a textured watercolour paper and the side of a soft pencil. Start by observing the proportions of the tree and making some appropriate guide lines. Then lay a middle tone over the whole area of the tree, picking up the paper texture and leaving some spaces or sky holes in the foliage area. Through half-closed eyes look for the main dark areas in the tree and reinforce these by using heavier pressure but still using the side of your pencil. Now look for any really light areas and using your putty eraser, remove tone to suit. Keep doing this until you build up a broad pattern of lights and darks that suggest the tree form. Look for branches going through any gaps in the foliage and put these in as silhouettes with the point of your pencil. The trunk is usually in shade, if only partial, from the overhead foliage and will show dark. The top area of a tree usually appears dark due to the fact that you are looking at the underside of the leaf masses, but the light source is from above.

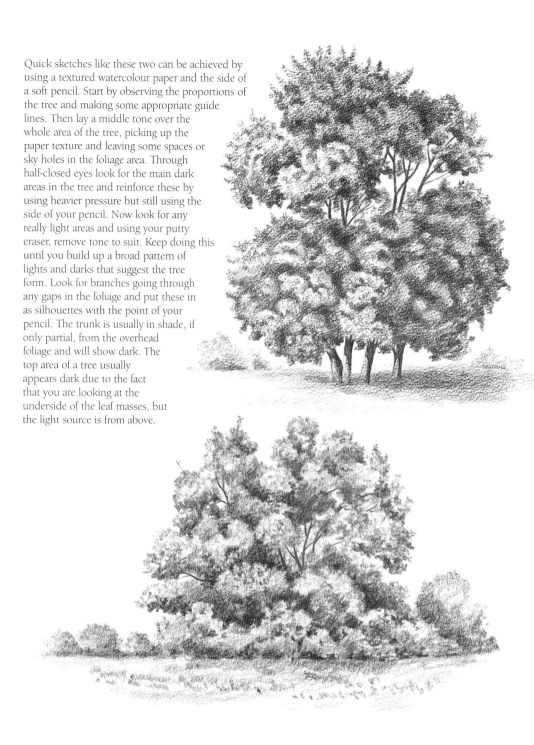

Drawing bare trees and branches

This pencil drawing was done using one of my ballpoint pen sketches as a reference (see page 16). The fact that the drawing is much larger than the sketch means that there is more space to fill, so you need more detail and textural information. Much practice and regular observation of bare trees and their details will help you to get to this point in your progress. You will develop a store of remembered features to help you create missing information in a drawing.

A range of subtle changes in tone will be required to form features such as these. Note that no lines are left visible.

I sometimes change the actual pattern of light against dark if this helps the viewer to understand more clearly what is happening. These overlapping branches might have looked more uniform in tone, but I have exaggerated the contrasts in order to show where one branch passes in front of another.

Split Bole Oak in Winter
330 x 260mm (13 x 10¼in)

18

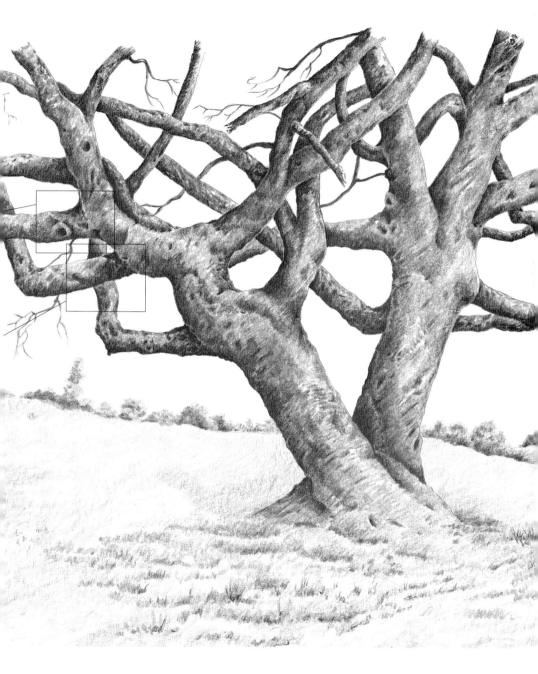

Bark textures

There may not be many situations where detailed bark rendering is called for but it can be quite eye-catching if used on a major tree in the foreground of a drawing. It will also prove to be a worthwhile learning and skill improving exercise.

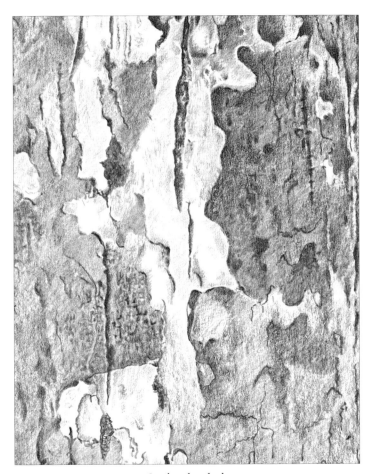

London plane bark

The London plane tree has quite a smooth bark, light grey in colour. It sheds thin flakes to reveal light patches of yellowish-green underbark. Subtle rendering is required to show this bark well: mostly side of pencil work using a range of pencil grades.

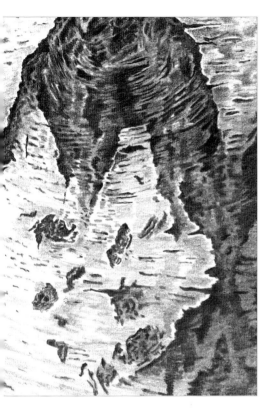

Silver birch bark

One of the most commonly recognised trees in winter or summer. The mature specimens have a warm white bark which contrasts with the deep black fissures that develop. This makes a good contrast in tones for a dramatic pencil drawing. Silver birches make excellent trees for the foreground, where you can show the bark texture to good effect. For this one you can really try out your different pencil pressures to create the contrast in tone. Note that the dark areas have a range of darks, and light areas have a range of lights. If you do not reflect this, your drawing will look flat.

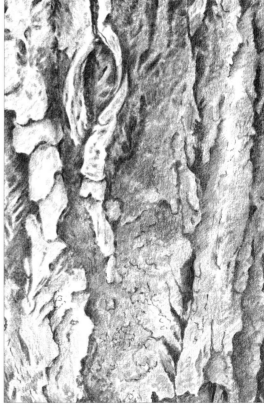

Weeping willow bark

This bark is grey-brown, sometimes showing deep, irregular-shaped fissures with fairly flat areas in between. It is very varied and a difficult bark to show well, but worth the practice. You will need to use lots of side and end of pencil work.

21

Leaves and seeds:
Oak Leaves and Acorn

For this drawing, some freshly found oak leaves with an acorn attached were placed on to a sheet of white paper. When drawing this type of subject, any unwanted leaves or stalks can be removed to improve the composition. In this case I wanted to work towards a clean, sharp-edged drawing, so I decided not to include any cast shadows.

Begin by looking at the proportions of your model. This one is approximately square.

Before starting to draw, remember to strike the pencil on a piece of scrap paper to form an edge or side that will make the marks you want. You will need a long, flat surface on the side of the lead for general toning or a flat on the tip for a more specific size of mark.

You will need
Pencils: 2B, 4B and 6B
Putty eraser
Paper rubbing stump
Heavyweight cartridge paper
Scrap paper
Impressing tool (a clutch pencil with a nail in it)

1. Using the 2B pencil, begin by lightly blocking in the external shape. Place some guide lines for the angles of the central veins in each leaf. Spend enough time to ensure a good foundation for your drawing. As always, use a piece of scrap paper under your drawing hand to keep your work clean.

2. Check the proportions and angles one more time, using the same measured drawing method that you would use for a whole tree (see page 13). Then start to make an accurate outline drawing of the leaves and the acorn. Alterations to the outline drawing are made by making corrections before removing unwanted lines.

3. While you are working on the outline drawing, you need to give attention to both positive and negative shapes (shown in red and blue respectively). This will help to make your drawing more accurate. The leaf veining can then be drawn in lightly.

4. Using the impressing tool, follow the veining lines, applying pressure to impress a groove with the side end of the nail. It is important to do some pre-trials on identical paper to judge the depth and pressure required, as you do not want to damage your drawing at this stage.

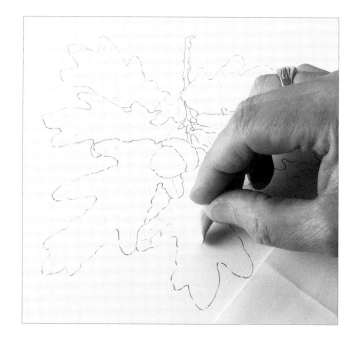

5. After the vein lines have been impressed, remove the guide lines with a putty eraser pinched at the end to get down into the impressed groove.

6. Sharpen the 2B pencil to a long point. Use this with the lead flat to the paper to tone over the impressed grooves. Make sure that the graphite of the pencil does not touch the impressed lines. Tone over whole leaf areas, leaving the impressed grooves white. If you work lightly, you will also pick up the texture of the paper.

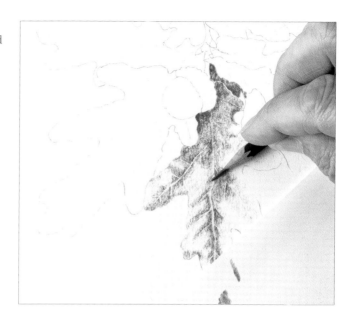

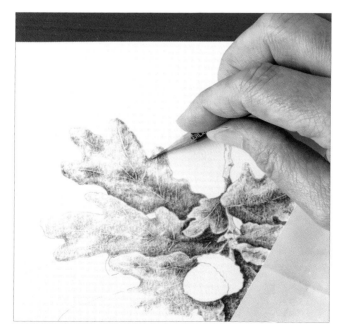

7. Use the three grades of pencil to give a variety of tones over the leaves. Darker tones help to show where the leaves overlap or where the leaf edges turn away from the light.

8. To make the acorn look smooth, apply a light tone with the 2B pencil and then rub this in one direction with the rubbing stump. Make the acorn darker at the outside edges and lighter in the centre. To make the highlight areas, squeeze the putty eraser to the width of the required highlight and use single strokes to remove some pencil work. Strengthen the tones either side of the highlights with a 4B pencil. The sharp tip of the 4B pencil should also be used on the patterned leaf at bottom left to create the raised, textured effect.

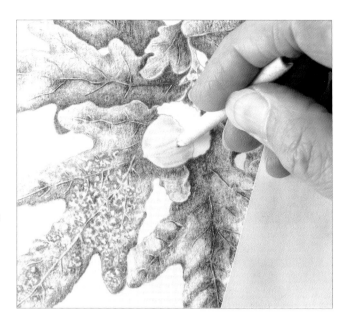

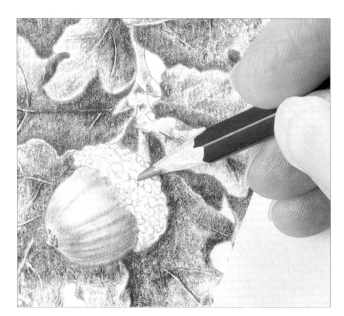

9. To make the acorn cup look textured and round, draw small, circular marks at the edges and larger circular marks around the centre of the cup. Vary these in thickness and density to give variety. Apply varying tones between these marks. Lift highlights with a pointed putty eraser where required.

Oak Leaves and Acorn
180 x 190mm (7 x 7½in)

At the final stage, work over the whole drawing, increasing tones with the 6B pencil and lightening where required with the putty eraser. When the drawing is complete, clean around the edges and any other areas that require it, using your putty eraser. The finished drawing can now be signed and framed. Alternatively it can be stored after lightly spraying with a fixative.

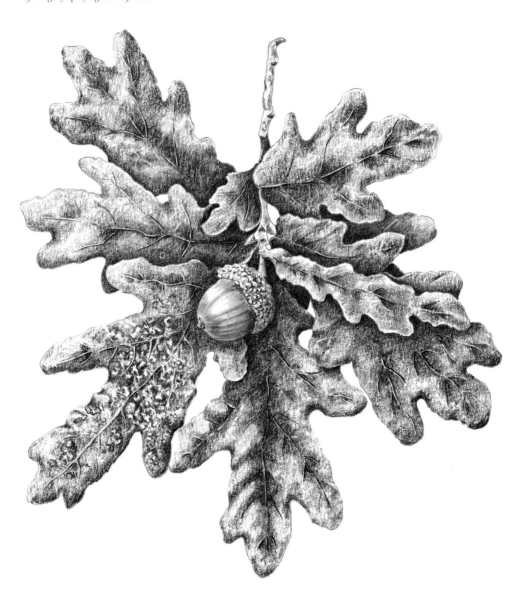

Spanish Sweet Chestnut
180 x 203mm (7 x 8in)

This drawing was done on plain photocopier paper. I did not, therefore, use an impressing tool for the veins – I simply drew round them. This is not as difficult as it first appears. It helps you to build up to the task of drawing those spiky nut shells, which are achieved by drawing darks around where you want light spikes to show.

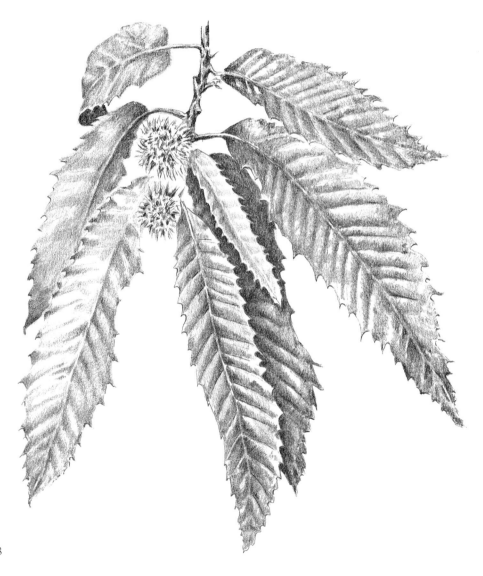

Ash Leaves and Seeds
203 x 152mm (8 x 6in)

Smaller foliage samples like these can be placed on a white plate and sealed in with plastic food wrap to slow down any drying out and curling up while you draw. Good observation is the key to improving your drawing skills.

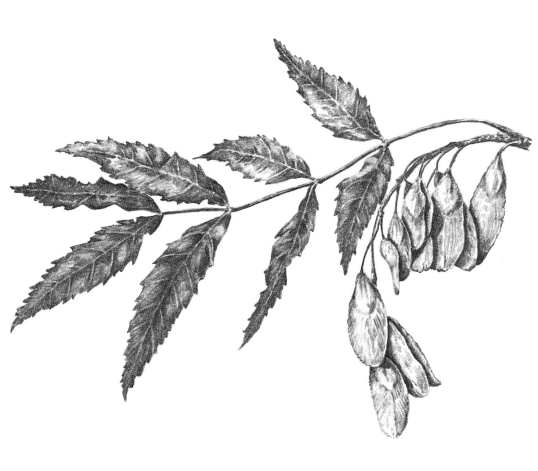

Light and shade: Lombardy Poplars

This tree's tall, elegant shape is useful in landscape drawings as it links into the sky space and balances out horizontals in the composition. Two trees together and overlapping give the opportunity to use contrasting tones of light against dark against light. Make a point of observing trees in a strong side light. This will help you to grasp this important principle.

I planned this drawing using the sketches shown below, considering the elements of composition, shape and tone that are all part of the process of designing a picture. To introduce variety and interest, I made the two trees different in height, with one of them in front of a hedge and the other growing up through it. I had some photographs of other Lombardy poplars for texture reference. A drawing like this one will take some hours to complete, so the main body of the work is always done back in the studio. I do not usually draw any one tree or group of trees on site for more than a couple of hours at a time as the changing light alters the light and dark patterns of trees too much. This is where sketching becomes most helpful, since you can get quite a lot of information down on paper in a relatively short time.

<div style="border:1px solid">

You will need
2B, 4B, 6B and 8B pencils
Putty eraser
Heavyweight cartridge paper
Scrap paper

</div>

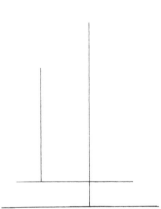

In planning your composition, it helps to balance the verticals and horizontals. Tall trees like poplars are useful for this reason in a landscape drawing.

Two trees together create an interesting variety of shapes.

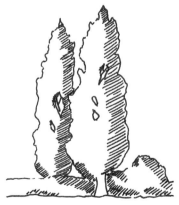

Look for the play of light. Overlapping trees create contrasts of light against dark and dark against light.

1. With a sharp 2B pencil, make a series of squiggles and dots to indicate the general shape and placement of the whole composition. Include some space for a little foreground work. Once you are happy with the shape and size of the drawing, add some general toning to suggest form and the direction of the light. Mark in where the branches are going to be.

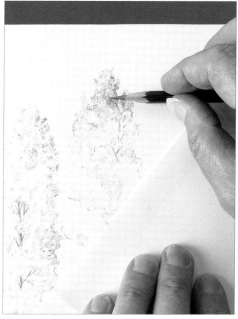

2. Lay in more tone to indicate further form, with the side of the 2B pencil. The texture of the paper grain can remain, as it almost looks like foliage. Work over the areas that will eventually be darker to gain a feel for furthering the form, before making final marks. Refine the branches.

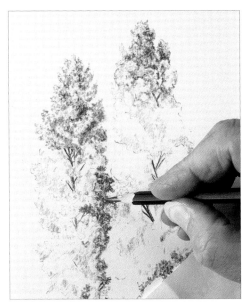

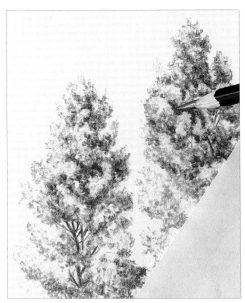

3. Make a good flat on the side-end of the 2B pencil and lay in some heavier tones to divide the area between the two trees. Apply similar toning to the dark areas under the trees and around the bole of the tree in front.

4. Using the 4B pencil with a flat on the tip, work some darker tones to further divide the large leaf masses. Notice that the tones are mainly laid down as marks, not as solid filled in areas.

5. Use the 4B pencil to darken the hedge under the main tree around the bole, render the fluting on the bole and indicate a cast shadow at an angle across it. Further render the left-hand tree and hedgerow with the same pencil. With the side of the 2B pencil, make some marks on the foreground area to indicate undulations in the field.

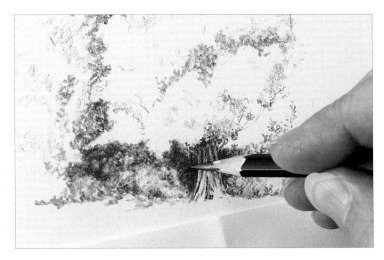

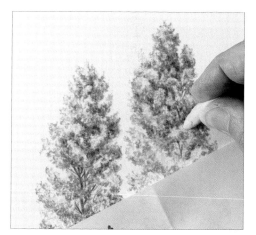

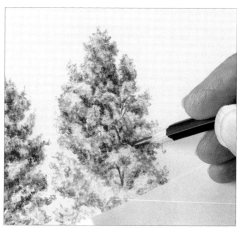

6. Lift areas of tone using a putty eraser if required to vary the shape and size of the leaf masses. Note the larger leaf masses on the most prominent tree.

7. Using some scrap paper, work a small flat on the end of your 6B pencil. Use this to make some darker tones within the previously made tonal areas. As you use this soft pencil, the flat will get larger. Do not let it get too large before re-forming it.

8. Establish the darkest area around the right-hand tree bole to help accentuate the features of fluting and cast shadow. This is the light against dark against light principle, which creates interest and drama.

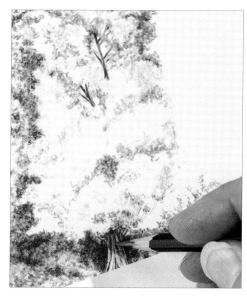

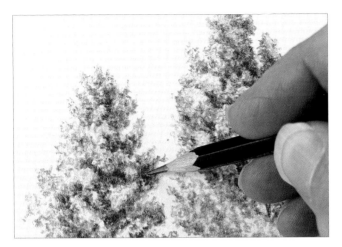

9. Using the 4B, 6B and 8B pencils, further establish the lights and darks of the main tree's large leaf masses. Lift areas with the putty eraser where required. Continue working in this way to near completion.

10. Work some detail into the rest of the hedge. Add some stray branches at the right-hand side of the hedge. Introduce some more foreground marks. Put the drawing aside for a while before looking it over for any further corrections that may need attention. Work to completion.

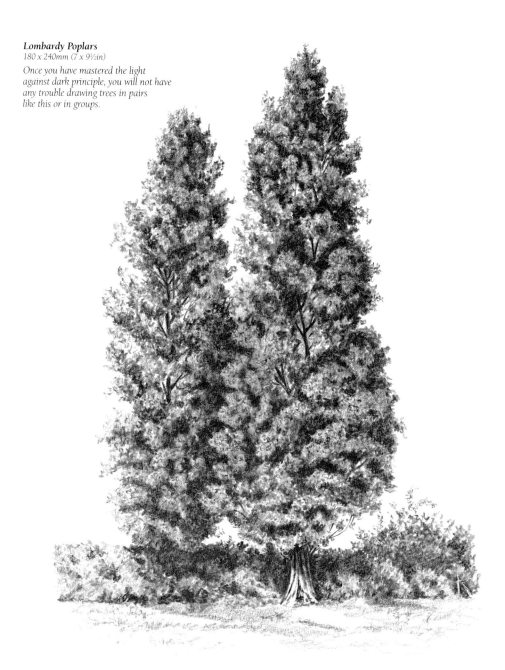

Lombardy Poplars
180 x 240mm (7 x 9½in)

*Once you have mastered the light
against dark principle, you will not have
any trouble drawing trees in pairs
like this or in groups.*

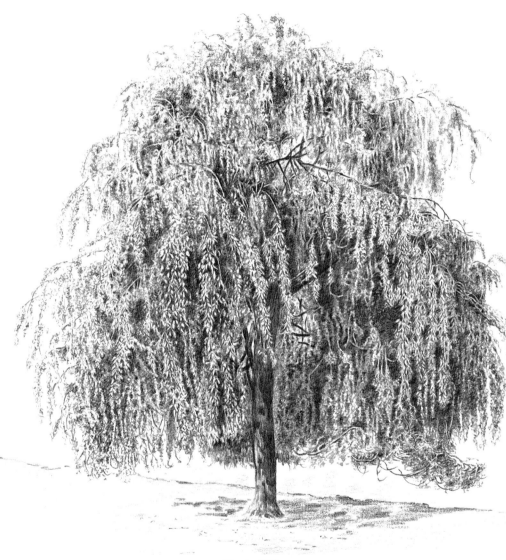

Weeping Willow
280 x 265mm (11 x 10½in)

I find these difficult trees to draw – perhaps because I haven't practised as much as I have with other trees. Do not be put off if you need a few attempts before you are satisfied with your efforts.

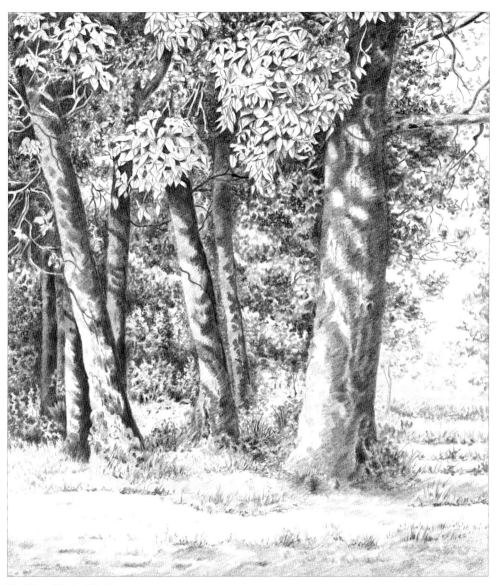

The Edge of Poplar Woods
195 x 215mm (7¼ x 8½in)

*This drawing was very time-consuming but worthwhile. Again it is
the dark tones that give the impression of light in the drawing.*

Contrasts in scale: Sequoia

A different approach was needed for this very tall tree, known in some parts of the world as Wellingtonia. A detailed rendering would have taken many hours, so I sketched it first and completed it in the studio. As the sun moves around, it lights trees from different directions, and this constantly changes the lights and darks that are so essential to the observation process required to draw a tree.

Standing in a position where the lighting was to my advantage, I took some photographs of the top and bottom halves of the tree, rather than attempting to fit the whole tree in one frame. This allowed me to get close enough to record the features required for a detailed drawing.

I will show how to render this tall, slender tree in three sections from top to bottom. The marks used to create form and texture will be increased in size in each section down the tree, to give the impression of the lower section being nearer to the viewer than the top.

You will need
Pencils: 2B, 4B and 6B
Cartridge paper
Putty eraser

I joined two photographs in order to have a detailed enough reference source for this drawing. Photographs should be used as reference for things you don't recall rather than to copy. I tend to choose the bits I like and use them where I think best. I also did a ballpoint pen sketch of the tree, shown above.

1. Make faint marks with a 2B pencil to indicate the tree shape and major groups of foliage. I do not use continuous lines at this stage, as I find them restrictive and they only need to be removed later.

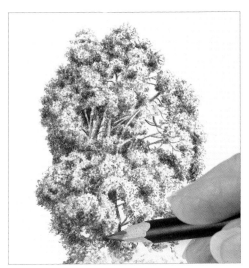

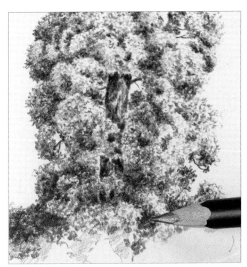

2. The light source comes from above right, so the left side and underneath of the foliage masses will be darker, and the left-hand side of the tree will look the darkest. With this in mind, start making marks with the end of a 2B pencil: a variety of dots, squiggles and blotches. The marks in this first section will all be of a similar size, but their density will vary in order to build up a pattern of lights and darks. Re-sharpen your pencil when it wears down, or the marks will keep getting larger. Branches are usually seen through the holes in the foliage, which also casts shadows on them. Mark these in with your 2B pencil. Use the shaped putty eraser and a dabbing motion to lighten areas. Darken some of the underneath areas with the 4B pencil.

3. Using the same mark making technique, but with a slightly larger flat on the end of your 2B pencil, work the second section. Along with the larger marks, make the clumps of foliage a little larger. The thick, twisted trunk showing in this section will have light and dark areas on it. Use your 4B and 6B pencils to get good contrast in its shadow areas. The darkest areas should be worked with the 4B and 6B pencils.

4. In the third section make the marks, foliage masses and light and dark areas even larger. This makes each part of the tree look as though it is getting nearer as your eye moves down it. Render the dark shadow and fluting on the trunk with the 6B pencil. Use the 2B and 4B pencils lightly on their sides to finish the background foliage and the foreground shadow and undulations in the ground.

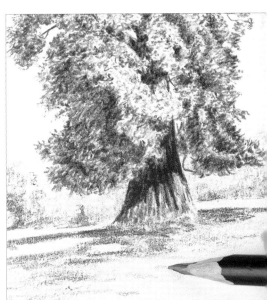

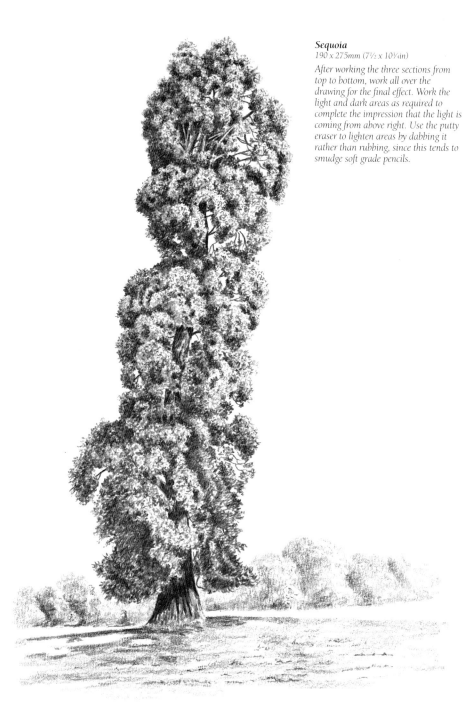

Sequoia
190 x 275mm (7½ x 10¾in)

After working the three sections from top to bottom, work all over the drawing for the final effect. Work the light and dark areas as required to complete the impression that the light is coming from above right. Use the putty eraser to lighten areas by dabbing it rather than rubbing, since this tends to smudge soft grade pencils.

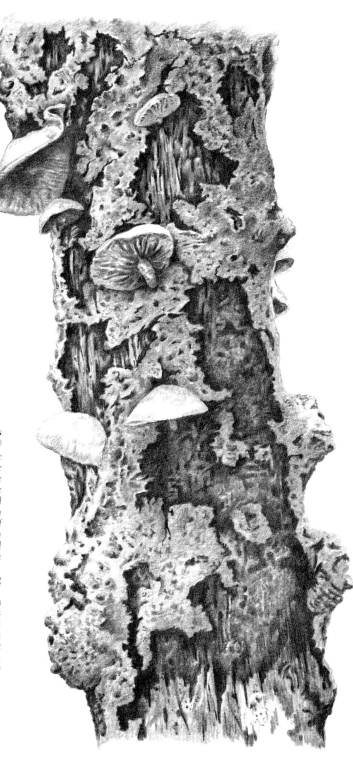

Tree with Fungus
185 x 290mm (7¼ x 11½in)

A drawing like this does not present the same perspective problems as the one opposite, but many of the challenges are the same. Whether depicting a whole large tree or just a section of a small tree, the drawing should contain enough information, in the form of marks and the variety of tones, to retain the viewer's interest. The individual marks can be quite abstract, but as a whole they can strongly suggest reality. The initial sketches for this drawing were done in an arboretum in Wales. As with the much larger scale Sequoia drawing, photographic reference was used because of the length of time it takes to complete a work with this amount of detail. For a piece of work like this I first make a line drawing, then use this to trace the image on to my final drawing sheet.

Trees in the landscape: Bankside Birches

Landscape drawing will sometimes involve capturing tree reflections. In gently moving water, reflections can break into all kinds of abstract, fragmented shapes. The distance that a reflection extends below the waterline can be taken as equal to the height of that object above the waterline. The size of object and reflection can be taken as equal. However, the reflection may be carried further by water movement.

You will need
Pencils: 2B and 4B
Putty eraser
Heavyweight cartridge paper
Tracing paper
Paper rubbing stump
Scrap paper

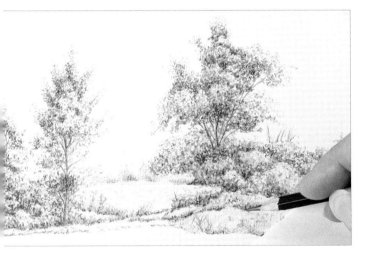

1. Using the 2B pencil, lightly mark out the proportions and placement of the landscape features. Progress the landscape area to a fairly complete state by carefully placing a variety of tonal marks using a 4B pencil. Reinforce and lift tones as required. Only after you are fairly satisfied with this step should you consider working the water and reflections.

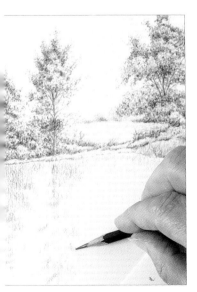

2. Use your pencil as a gauge to mark the lengths of the reflections below the waterline. Using short, vertical strokes with the side of your 2B pencil, start laying in some broad areas of light tone for the reflections.

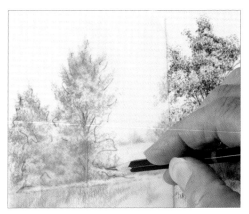

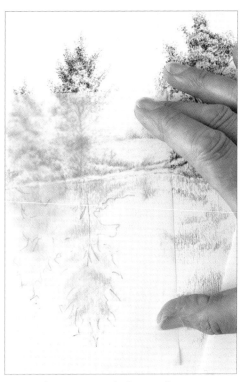

3. Continue with short strokes of the 2B pencil, noting carefully that where the actual tree branches grow upwards, their reflections will go downwards. If this is initially a problem, use some tracing paper to trace a rough outline of the trees.

4. Turn the tracing upside down and use it as a guide only to check your drawing of the reflection.

5. Now put in some of the darker tones with the 4B pencil and continue getting a general upside down likeness of the image above the waterline. With the side of the 2B pencil, sweep in some strokes of tone to give an indication of where the water ripples will be. Using the side of your finger, carefully smudge the graphite over the whole of the water area.

43

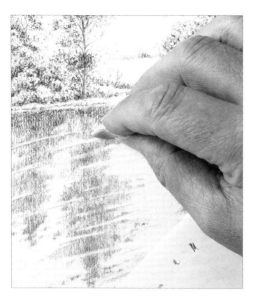

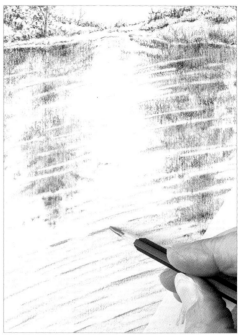

6. Continue with the 2B and 4B pencils, adding tone to give a stronger reflection. Then, using a putty eraser pinched to a thin edge, remove some areas of tone at the far edge of the water. Work in the same direction as the ripple marks. Increase the width of the removed areas as you come forward in the picture. Note that parts of the reflections are carried away along the line of the ripples.

7. Using your 4B pencil with a small flat on its end, apply some further tone to the front edge of the areas that you previously cleared with the putty eraser. This will add depth to the ripples.

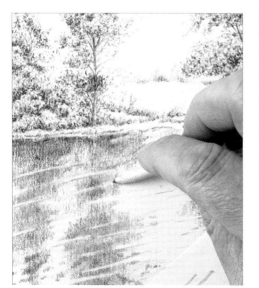

8. With the rubbing stump, gently smudge some pencil marks to hide the grain of the paper, adding another texture to the water surface. Continue adding and removing areas of tone, making these features more prominent by means of size and contrast the nearer you move towards the foreground.

Opposite
Bankside Birches
210 x 297mm (8¼ x 11¾in)

The drawing merely creates an impression of the scene. For rougher water the reflections would be even more fragmented, whereas for smoother water the reflection would show more detail, almost like a mirror image.

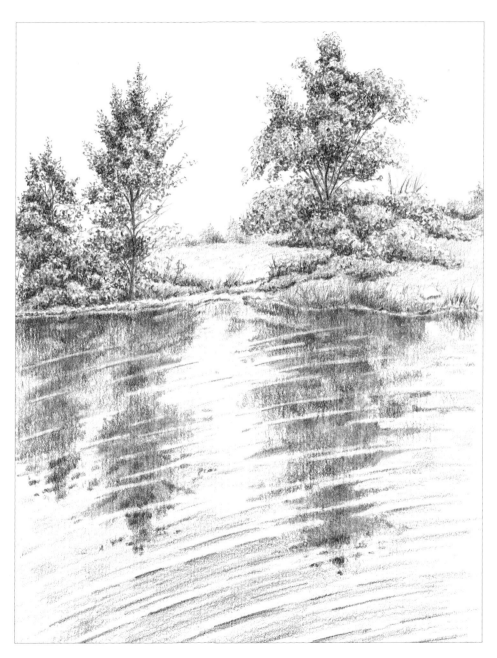

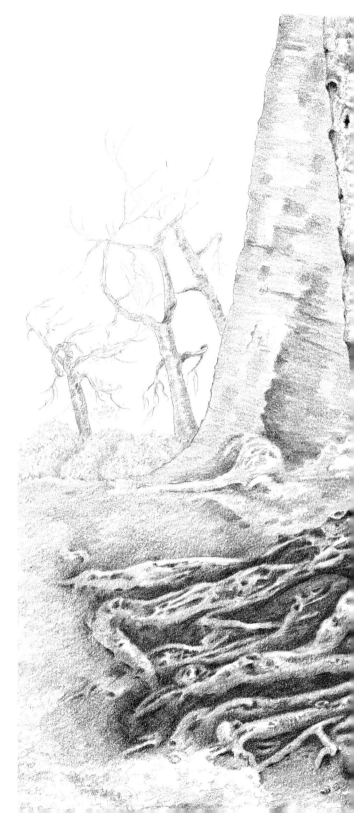

Tree Roots
350 x 285mm (13¾ x 11¼in)

This landscape drawing is on a different
scale, and contains more detail of an
individual tree. Only where the water
has washed away the soil will roots be
exposed as they were here, by the bank
of a dried up or diverted river.

46

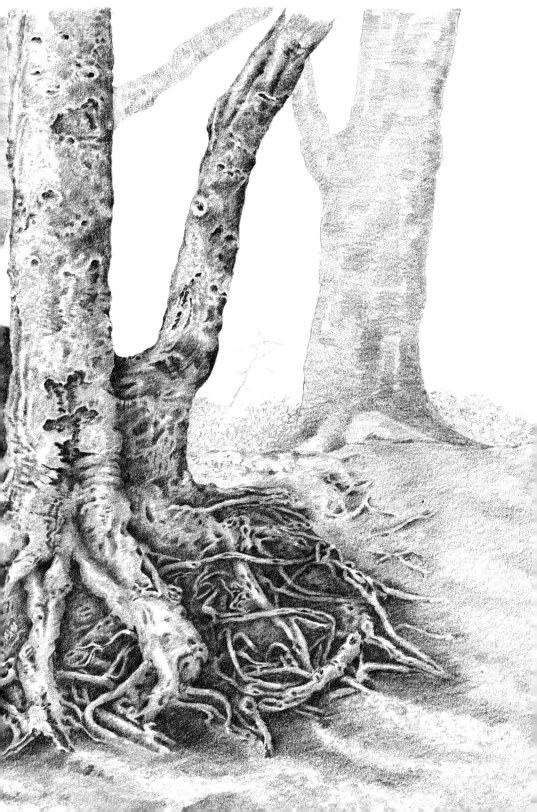

Index

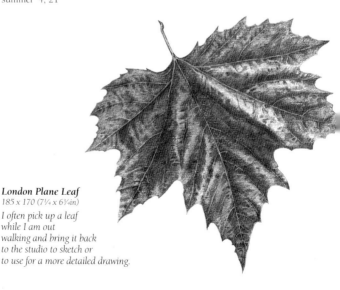

London Plane Leaf
185 x 170 (7¼ x 6¾in)
*I often pick up a leaf
while I am out
walking and bring it back
to the studio to sketch or
to use for a more detailed drawing.*